An exhibition of a book
dedicated by Henry Moore to WH Auden
with related drawings

Auden / **Moore**

poems lithographs

Published for the Trustees of the British Museum by British Museum Publications Limited

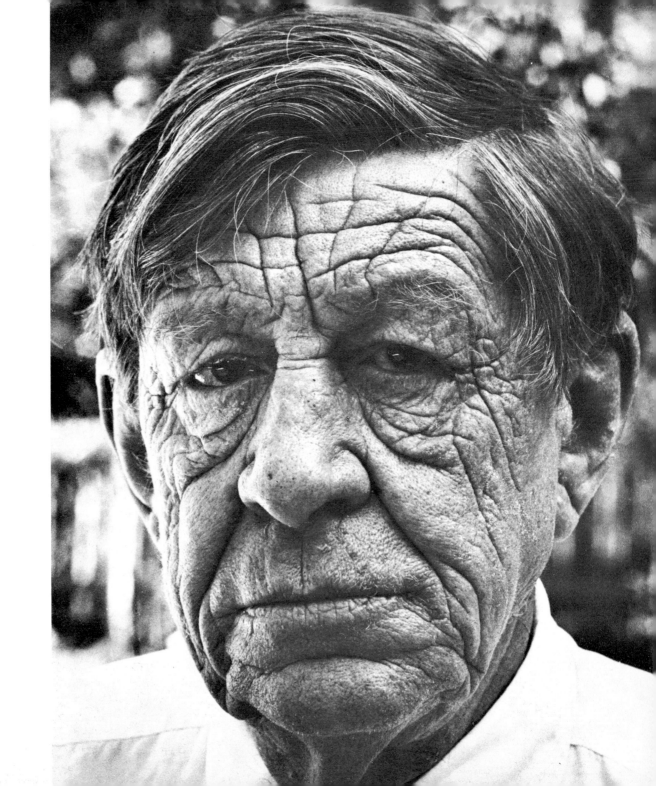

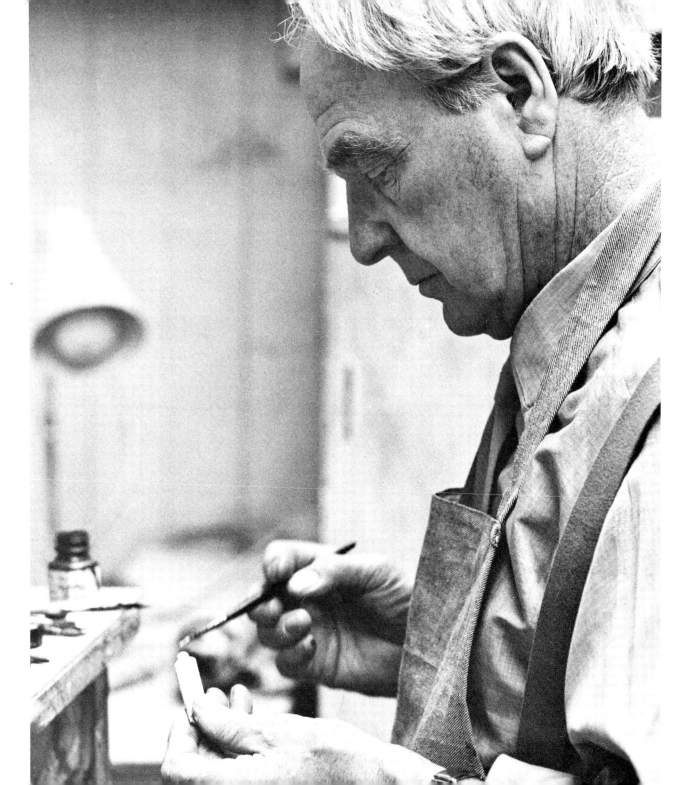

Preface

The nucleus of this exhibition is an advance copy, presented to the Department of Prints and Drawings by the artist, of the selection of poems by W. H. Auden illustrated – or, it would perhaps be truer to say, interpreted – with lithographs by Henry Moore, which the Petersburg Press is to publish later this year. A publication of this kind is an unusual departure on our side of the Channel. In France, since the appearance just a century ago of Mallarmé's translation of Poe's *Raven* with illustrations by Manet, bibliophiles have set a constant fashion for *éditions-de-luxe* of major works of literature embellished by major artists. Here no such tradition exists. We might, it is true, point to Richard Bentley's *Designs for Six Poems . . . by Mr Thomas Gray*, published in 1753; Blake, though he likewise drew illustrations to Gray as well as to Dante and Milton, never published any of these in book form, but we have his *Job* engravings and his *Virgil* woodcuts while his genius has embalmed two otherwise forgotten works, Blair's *Grave* and Young's *Night Thoughts*; Samuel Rogers, a better connoisseur than poet, had the good taste to commission Stothard to decorate his *Pleasures of Memory* and Turner to illustrate his *Italy* – of which it was said 'it would have been dished but for its plates'; the few drawings that Rossetti, Millais, and Holman Hunt made for the great illustrated *Tennyson* of 1857 are some of their finest, but the total effect of the book is much diminished by the more numerous contributions from less talented hands. But these are the rare exceptions that prove the rule: the convergence in the Auden/Moore volume of a great English poet and a contemporary English artist of equal stature is a remarkable event.

Henry Moore is primarily a sculptor; but if by some unimaginable disaster his sculptures were totally obliterated, his drawings, etchings, and lithographs would still establish him as one of the major artists of the time. He has taken the opportunity provided by setting the Auden lithographs in the context of the work that preceded them, to make a statement, implicit in the choice and sequence of the exhibits and

explicit in notes written especially for the catalogue, about some of his own attitudes to drawing. Given the nature of many of the Auden lithographs, it is natural that he should lay special emphasis on what he calls his 'black' drawings. These include the still little-known Coalmine series of 1941, among them the magnificent sketch-book, never reproduced or previously exhibited, where he recorded his first impressions while still fresh in his mind. The 'black' drawings, in which he seems, like a mezzotint engraver, to be working from dark to light, owe much (as he is the first to admit) to Seurat. However revolutionary-seeming the formal language in which he has chosen to express himself, Moore is essentially a classical artist in his ceaseless preoccupation with form and with form in space, and in his awareness of his debt to the past. All great artists are contemporaries; and as prelude to the exhibition he has picked out a dozen or so drawings and prints by such elder contemporaries as Michelangelo, Seghers, Rembrandt, Turner, Millet, Redon, and Seurat, which seem to him particularly relevant to his own formation and to his practice as a draughtsman.

The Department of Prints and Drawings wish to thank all those who have collaborated in the exhibition: those who have generously lent their drawings to it; the Petersburg Press and also the Curwen Studio for having produced an advance copy of the book at a time of exceptional industrial difficulty; Véra Lindsay, who first suggested the idea of the book, who has been largely responsible for its design, who first proposed the exhibition, and whose help in planning it and in compiling the catalogue, with David Mitchinson, has been invaluable; and, above all, Henry Moore himself, for devising its theme and for expounding it in the catalogue.

JOHN GERE
Keeper of Prints and Drawings

Auden / Moore
by John Russell

It was a great poet, Paul Valéry, who said (most probably with Degas in mind) that 'There is an enormous difference between seeing something without a pencil in one's hand and seeing it *while drawing it* Drawing an object from life gives the eye a certain authority. That authority is fed by our will. We must *will*, therefore, in order to *see*.'

Drawing of that kind has played a great part in the career of Henry Moore. Sketch-book and pencil are never far from his hand. Nothing can be entirely known, in his experience, until he has drawn it. Anyone who has been with him to one of the great museums of the world will have sensed a particular tautening of his attention when he gets to the Print Room and there is set before him a box of drawings. It was after one such visit (to the Albertina, in Vienna) that he said not long ago that 'To draw properly takes as much intellect as to run a country.'

On the evening before that visit he had seen – for the last time, as it turned out – the poet whose work had prompted a new turn in his work: W. H. Auden. The two had at a first glance nothing in common. Moore is what he always was: free, plain, and downright in his speech, at ease primarily in England, and with an outlook upon life which has deepened but not varied, in its essentials, since he first found his way as a sculptor. Auden had lived for more than thirty years as an exile, forming and unforming group after group of cross-cultural allegiances. He was ready to change, and to accept the consequences of that readiness, in ways that would not have occurred to Moore. But as the rightly illustrious figure padded in carpet-slippers along the countryfied street, past the house that had belonged to Franz Lehar, on his way back to the city in which he was so shortly to die, there was no mistaking the fact that a very extraordinary presence had left the room and that somehow, somewhere, there was an absolute rightness about his association with Moore.

As to where that rightness lay, the Auden/Moore book has the answers. Many of them are surprising. Moore lives for part of every

year in Italy, for instance; but when Auden gave up his house on Ischia and evoked

> My sacred meridian names, *Vico, Verga,*
> *Pirandello, Bernini, Bellini,*

we could not but think that of the five men in question only Bernini would be of real importance to Moore. Moore enjoys being in Austria – I have rarely seen him more evidently moved than at the birth-place of Haydn – but in no circumstances would he contemplate going into exile, there or elsewhere. Perhaps Yorkshire has some part in the palpable rightness of their association? Well, Auden was born in York, and could it be that the big-shouldered Yorkshire landscape, so fundamental to Moore's achievement, meant something special to Auden? I don't think we can count on it. The young Auden was unexcelled at the brisk and summary evocation of real places (remember, *Oxford, Dover, Macao,* and *Brussels in Winter*); and he was no mean hand, either, at the presentation of an imagined Elsewhere; but there was in all this an element as much of play as of identification, and rather more of sheer enviable cleverness than of the wish to stick with one primal experience. Auden in the poems of his twenties had the quality of a kingfisher's hither-and-thither dart; Moore, at that same time, was a burrowing and a digging animal.

In politics, Moore today is what he had always been: a nineteenth-century radical. Auden moved, between the 1930s and the 1970s, from the far left to a wry, churchy conservatism. As to that progression, many opinions can be held; but as he grew older Auden's curiosity became more and more encyclopaedic. Remembering how alembicated was his own poetical practice in later life, we find an added significance in the case which he made out, in the T. S. Eliot Memorial Lectures in 1967, for the Icelandic sagas as one of the completest and most admirable forms of human expression. For part of the point of the sagas was their plainness: their ability to tackle those elements of heterogeneity and accident which are fundamental to human life. The Icelandic language was, and still is, one in which (to quote from Auden) 'there was no difference between cultured and vulgar speech, nor between the spoken and the written language'. Remembering how Henry Moore uses exactly the same terms when making a formal speech in Paris as he does when passing the time of day in an English village shop, we begin to see him as an honorary citizen of that ancient Iceland where the current literature epitomized what Auden calls 'social Realism, not to be confused either with socialist realism or with naturalism'. It may also strike us that when Moore takes a heroic

subject there is something in his way of handling it which is both verocious and laconic. If he should verge for once on one of those lofty and explicit general statements which recur – 'Sunt lacrimae rerum . . .' – in European epic, he is likely to slip in an anatomical detail which brings us back to what Auden called the heterogeneous and the accidental. An actual hand, a known shoulder, even a particular pelvis seems to draw us away from the world of general statement towards a world in which there is only one of everybody and that one deserves to be identified.

Very good writers feel when they are young as if no one had ever written before: or, at the very least, as if no one had ever written quite like them. There is much of this in early Auden. But in middle and later life he began to feel, with Lichtenberg, that 'I have drawn from the well of language many a thought that I did not have and could not put into words'. He realized, that is to say, that what we have to say is likely to be prompted by the totality of language. What goes under our name is rarely more than borrowings; Auden went on to quote from Rosenstock-Huessy to the effect that 'Living language always overpowers the thinking of the individual man. It is wiser than the thinker who assumes that he thinks whereas he only speaks and in so doing faithfully trusts the material of language; it guides his concepts unconsciously towards an unknown future.'

The history of the arts in our century would seem to bear this out. In their twenties, the big men may seem to take on the past single-handed; but as they grow older it becomes clear not only that they welcome the collaboration of the past but that, in almost every case, they have been doing it all the time. Brahms stood sponsor to the young Schoenberg, though it took a long time for people to notice it. The whole of European poetry stands behind *The Waste Land*, the whole of European painting behind Matisse, the whole of European drama behind *Waiting for Godot*. These things only make complete sense in the context of what went before them; and they are enhanced, not diminished by that fact.

Auden was much too good at monitoring his own states of mind not to know when to 'trust the material of language'. The major artist, in this context, is the one who can draw at will upon the accumulated energies of the past. Where others presume to invent, he waits and watches. In time, the unforeseeable will make its way into his consciousness; and there will emerge a 'new period' for the historian to codify. Something of this sort happened when Henry Moore was invited to illustrate the poems of Auden. Commissions of this sort are

sometimes welcome, sometimes not; when Matisse was working on his big decoration for the Barnes Foundation, nothing would have persuaded him to take on an illustrated book. But when that decoration was up on the wall in Merion, Pa, he welcomed a change of activity. This was what happened to Moore; for one reason or another he was delighted to try his hand at something new – and all the more so if it allowed him to explore certain feelings about drawing which were in the forefront of his mind.

Now, Moore has been making drawings, and looking at other people's drawings, and thinking about the nature of drawing for well over half a century. Drawing seems to him to be fundamental to awareness: 'no photograph can give you the true shape of things', he will say. No one is more generous than he when it comes to acknowledging, in this respect, the collaboration of the past; nor is anyone more diligent, more free from prejudice, more genuinely ready to learn. All over the world there are people who remember the great schoolboy's cry of delight with which Henry Moore will greet a fine drawing not previously known to him.

Fixed ideas about drawing seem to him self-evidently a mistake. As a young sculptor at Leeds School of Art he was taught that late Ingres was better than early Ingres. It did not strike anyone as ridiculous that 20-year-old students should ape the procedures of an 80-year-old man; yet 'You can't learn shorthand', Moore will say now, 'if you don't know longhand first.' In this context, 'knowing longhand' means having followed the traditional Beaux-Arts method of drawing: a shaded contour laid on top of white paper and finished as near as may be. Copying real life in this way now seems to him at best a serviceable compromise: 'the paper is never as white as bright light, nor the pencil as black as darkness'. One man and one only had gone through to a completely new way of drawing; and that man – Seurat – had been in his student days a particularly conscientious exponent of the Beaux-Arts method.

Henry Moore's lithographs for Auden are not foisted on the poems, as sometimes happens with a commissioned book. They arise from the specific experience of one poem after another. But it is no disparagement of their quality to say that they also arise from the experience of living with Seurat drawings, and of looking around, perhaps not quite consciously, for subject-matter that would allow Moore to trust 'the material of language', as Seurat had bequeathed it to his successors. Moore needed to move outside his normal preoccupations before he could hazard himself in the new medium;

and Auden made this possible. The poems were most suited to his purpose when Auden did not explore a subject fully but gave it a searching, momentary glance and passed on. 'He left the suggestiveness of landscape intact and unexplored', Moore said lately. 'And I've always loved landscape. I can never read in a train. I have to look out of the window. Of course the distances in landscape are completely different from the distances in an interior, but when you're drawing it's fundamentally the same problem – hand to ear, tree to mountain, it's all one.'

Auden told us of his preference in landscape:

> ... when I try to imagine a faultless love
> Or the life to come, what I hear is the murmur
> Of underground streams, what I see is a limestone landscape.

But what Moore got from the poems was not, I think, a one-to-one transference of the kind which that passage might evoke. It was, rather, an authorization to let his imagination go free. From time to time throughout his career he has produced a small group of images for which no warrant can be found in his own experience: shipwrecks, perilous incidents of travel, inexplicable scenes in interiors, and fully worked-up drawings like the famous one of a crowd looking at a tied-up object. Something of psychic energy courses through these images and makes them indispensable to the student of Moore. They have been let out only in ones and twos, and they have never taken over from the straiter discipline of drawing from the given object: but they have to be reckoned with, and there are quite a few of them in the Auden/Moore book.

They proceed quite naturally, as I said, from the text. For all the conversational banter of the late poems, Auden had few rivals when it came to creating disquiet with just a word or two. (Of the four voices which he once described as 'just audible in the hush of any Christmas', one said 'I smell blood and an era of prominent madmen'.) Moore has too vivid an imagination, and too lively a sense of human distresses, not to respond to the opening of *The Lesson*:

> The first time that I dreamed, we were in flight,
> And fagged with running; there was civil war,
> A valley full of thieves and wounded bears.
>
> Farms blazed behind us; turning to the right,
> We came at once to a tall house, its door
> Wide open, waiting for its long-lost heirs.

These are not images on which the Beaux-Arts tradition of drawing

can improvise. What was needed was a way of drawing that gave the observer the sensation of passing from a lighted room into a dark landscape. Outline must be ignored, and light and dark be made to do all the work. (No easy task, this latter: Conté crayons of the quality which Seurat used are no longer available.) Sectional contour-drawing of the kind which Holbein brought to perfection would be irrelevant; the paper must be used as Seurat used it, or not at all.

Long before he owned a Seurat drawing, Henry Moore had had practical experience of the way in which forms can emerge from the dark into the light. During his period of service as a war artist in 1939–45 he had occasion to go down the mine in which his father had worked many years before. Conditions were hellish, as he himself says elsewhere in this catalogue: the downward journey in the cage, the mile-long crawl to the pit-face, the noise of the coal-cutting machine, the inescapable dust, the no less inescapable smell of the coal, the faint and distant light of the lamps, the faces travestied by dirt, with noses so deeply engrimed as to be invisible and cheek-bones startlingly white. The white, licked lips in the black, black faces gave Moore a startling and dismaying idea of what it meant for forms to come forward from darkness. Only later did he realize that Seurat would have known how to render such a scene in its fullest three-dimensional reality.

Moore for many years did not care to show the mine-drawings, so that most of them are still quite unknown. But no experience is ever lost; and this particular one is right there in the Auden book, together with others of a more agreeable sort. If there is great pressure of feeling in the book, it comes in part from the medium, and from the continual struggle to make the medium bend to the artist's will. Seurat's procedures are inimitable, after all. Reproduction betrays them, because the tones come out too close, as if what was written for seven octaves on the piano had somehow to be compressed into two. Lithography with its fat velvety textures could come closer to the desired qualities, but even there was often too much grey in the black. There was a point, too, at which the images could become too explicit, and another at which they might have become unintelligible.

This book is one of the great adventures of recent art, and there are not many major artists who would hazard so much of themselves in their 70s. Or should we simply say that there are not many major artists, old or young? It is the mark of the major artist that he will risk all of himself at an age when the minor ones are content to coast home; and in the Auden/Moore book Henry Moore has risked all of himself and come out unscathed and enhanced.

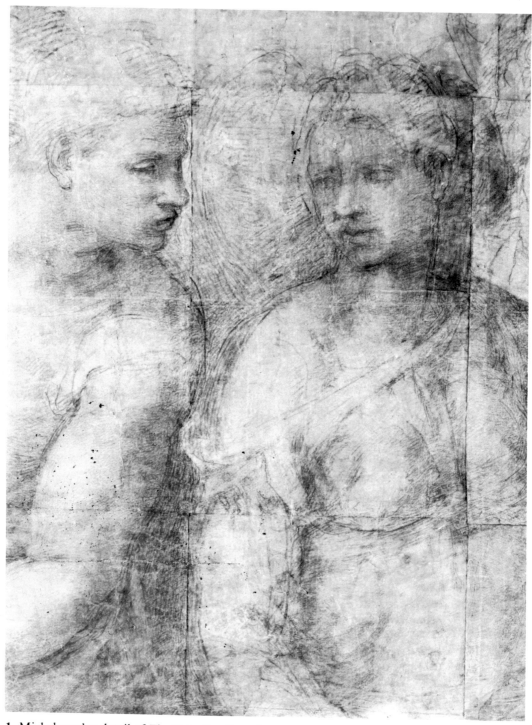

1 Michelangelo: detail of *The Holy Family with Saints*

Introduction
by Henry Moore

When the city of Florence offered to put on an exhibition of my
sculpture at the Belvedere, I found it a huge compliment, because I
love Florence and because Florence has meant so much in my life.
The invitation from the British Museum to show some of my drawings
and recent graphic work, centred on the Auden illustrations, was once
again a tremendous compliment. The British Museum, like Florence,
has had a great influence on my life and work, for it is there above all
that I have had the opportunity of studying some of the greatest
sculpture and drawing.

The opportunity of choosing a few prints and drawings, mostly from
the Museum's collection, which help to explain some directions in my
own work, and of having enough space to surround the Auden
illustrations with drawings of my own that seem to me relevant to
their making, is a fascinating one. I hope that by seeing the illustrations
in this context people may understand them better. In the various
sections of the exhibition I have attempted to explain some of my
attitudes to drawing. To begin with, there are a few drawings and
prints from the past which I love and which therefore have influenced
me (these include the large Michelangelo cartoon on permanent
exhibition opposite the entrance to the Prints and Drawings Gallery,
which for me is one of the world's greatest drawings); then there are
some of my early life-drawings in which I learnt to draw and
understand the human figure; these are followed by pictorial drawings
and drawings for sculpture which illustrate my preoccupation with
making shapes in space on a flat sheet of paper – pushing and
destroying the surface to create the effect of solidity, depth, and
distance.

The pictorial drawing called *Crowd looking at a tied-up object* has a
close affinity in theme to my interpretation of the Auden poems – the
mystery of what is under the shroud is somewhat akin to the mystery
in poetry. It is this element of the unknown that fascinates me in caves
and the holes in the sides of hills – you don't know what is there until

you look and explore into them. This mystery excites the imagination, and poetry has the same multi-meaning that makes you explore it in depth. In the same way, there are drawings and prints that you can look at for long periods and return to again and again, always discovering new meanings. Rembrandt's etchings do this for me: it is wonderful how he makes shadows that have mysterious, unbelievable sonorities. Turner, whether on canvas or on paper, can create almost measurable distances of space and air – air that you can draw, in which you can almost work out what the section through it would be. The space he creates is not emptiness: it is filled with 'solid' atmosphere. In Hercules Seghers there is a mystery in the depth and the modelling. By the slightest change in tone and technique he can push a surface back, giving it a sensitivity of form only just discernible in its subtlety.

The full possibilities of spatial drawing cannot of course be shown in the work of only one person, so these examples from the past may help explain my search. There are many ways and styles of drawing, and many objectives and themes. None comes fully-fledged, and everything that happens has a history. In this exhibition I have tried to show some of the steps that preceded the Auden illustrations – steps that go back over nearly half a century.

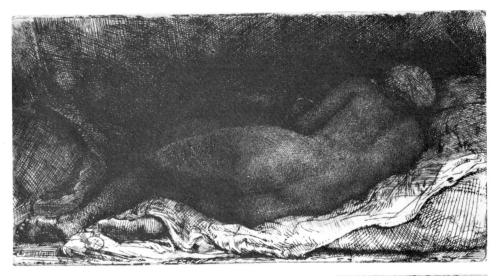

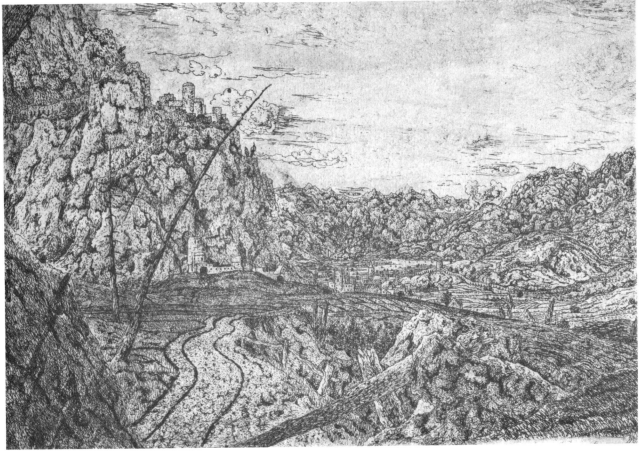

8 Rembrandt: *A negress on a bed* **4** Seghers: *Rocky landscape with a plateau*

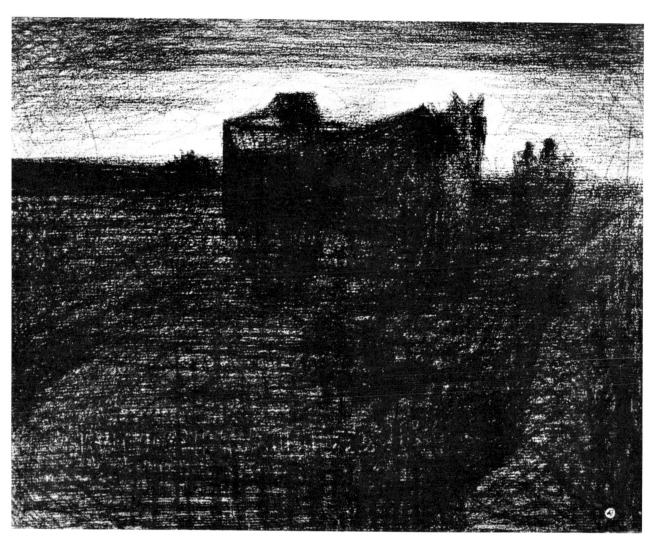

14 Seurat: *Les deux charrettes*

1 **Michelangelo** (1475–1564)
The Holy Family with Saints (*the 'Epifania'*)
Black chalk. A cartoon made by Michelangelo probably not long before 1550, for his friend and biographer Asciano Condivi (*c* 1525–1574), who used it as the basis of a painting now in the Casa Buonarroti in Florence. The title *Epifania* is given to the cartoon in an inventory drawn up after Michelangelo's death.

2 **Michelangelo** (1475–1564)
Christ on the Cross between the Virgin and St John
Drawing. Black chalk and white bodycolour. One of a number of drawings of the subject datable on grounds of style in the late 1550s.

3 **Michelangelo** (1475–1564)
The Virgin and Child
Drawing. Black chalk. A very late drawing, probably even later than the *Crucifixion* series (see no 2).

4 **Hercules Seghers**
(1589/90–1637/8)
The rocky landscape with a plateau
Etching, printed in blue on paper tinted with thin yellowish-green oil or bodycolour (Singer 17).

5 **Hercules Seghers**
(1589/90–1637/8)
The large landscape with the shattered pinetrees
Etching, printed in black on paper tinted with thin pale brown oil or bodycolour (Singer 27).

6 **Rembrandt** (1606–1669)
The Sacrifice of Isaac
Drawing. Red chalk and Indian ink wash (some black chalk on left). Signed. A study for a painting dated 1635 (Leningrad) or for a variant dated 1636 (Munich).

7 **Rembrandt** (1606–1669)
The Entombment
Etching. Datable *c* 1654. Two impressions of the fourth and last state. The one on the right is a proof pulled by Rembrandt himself, with 'surface tone' (*ie* from a plate not wiped clean but left with a thin film of ink) and with touches of white bodycolour on the arms and legs of Christ (Hind 281).

8 **Rembrandt** (1606–1669)
A negress on a bed
Etching. Signed and dated 1654 (Hind 299).

9 **Rembrandt** (1606–1669)
A sleeping girl
Drawing. Brush in brown ink. A late work.

10 **Joseph Mallord William Turner** (1775–1851)
A storm in the Alps
Watercolour. Finberg describes the subject as 'a mountain pass' and dates the drawing in the decade 1820–30. He may be right in suggesting that the drawing is a reminiscence of something seen by Turner on his way back from Italy in 1820, but the broken brushwork suggests a somewhat later date, possibly *c* 1835.

11 **Jean-François Millet** (1814–1874)
The window
Drawing. Black chalk. The artist's initials are from the stamp applied after his death to drawings found in his studio.

12 **Odilon Redon** (1840–1916)
A tree-trunk
Drawing. Black chalk or charcoal

13 **Odilon Redon** (1840–1916)
Le jour
Lithograph. Plate 6 of the series *Songes*, published in 1891 (Mellerio 115).

14 **Georges Seurat** (1859–1891)
Les deux charrettes
Drawing.
Collection: Henry Moore.

15 **Georges Seurat** (1859–1891)
La lampe
Drawing.
Collection: Henry Moore.

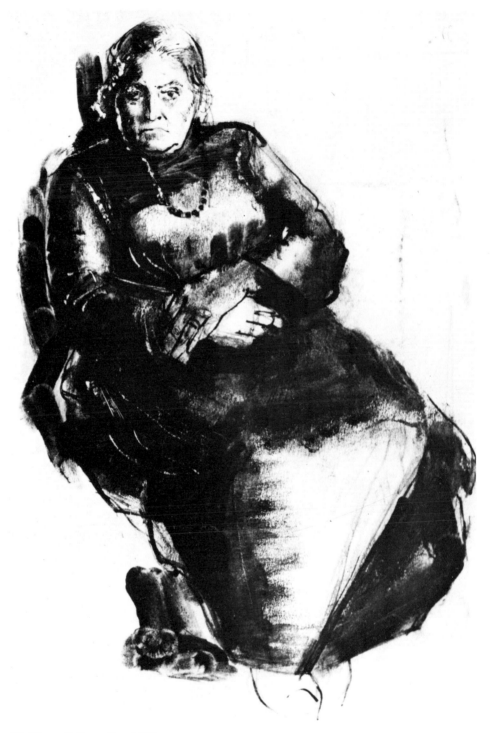

22 The artist's mother 1927

Section one
Life drawing

For me, life-drawing has been a continual struggle to understand the complete three-dimensional form of the model and to express it on the flat surface of the paper.

There are two main methods of drawing. One, based on outline and linear perspective, is a kind of shorthand notation of form. But an outline represents a boundary, and this you must begin by destroying if you want to place an object fully in space. The other method of drawing is concerned above all with light and shade, using the white of the paper to represent the surfaces that reflect the most light, and the various intensities of blackness provided by the medium – pencil, charcoal, conté crayon, etc – to indicate the extent to which the other surfaces are turned away from the source of light. The shape of the object is shown by gradations between the whitest white of the paper and the darkest black of the medium. In fact, since we can only apprehend shape in terms of light, any three-dimensional drawing is a mixture of both methods.

One must explore space and depth and light and shade over and over again. If you take the two great modern draughtsmen, Matisse and Picasso, you will find that in their early and middle periods both have drawn in this highly modelled way.

In the section of life-drawings I have tried to explain what led up to the 'black drawings': to show that their basis, like that of Seurat's late drawings, is founded on solid three-dimensional light-and-shade drawing. Seurat, who began by making light-and-shade life-drawings in the Ecole des Beaux-Arts tradition, came gradually to develop an entirely new way of drawing, using no outlines and fusing together space and form, light, depths, and distances into a marvellous and mysterious unity of vision.

People so often think that in drawing one uses only one's intellect and intelligence, leaving out emotion and sympathy. This is not so, because one cannot observe clearly without understanding and feeling.

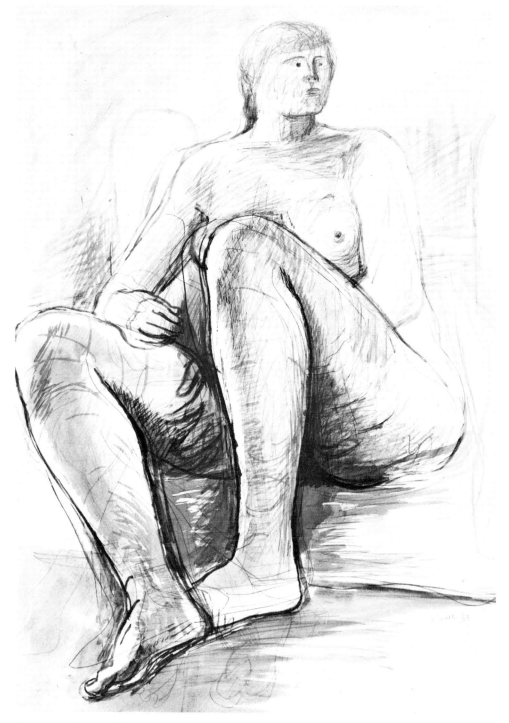

27 Seated figure 1933

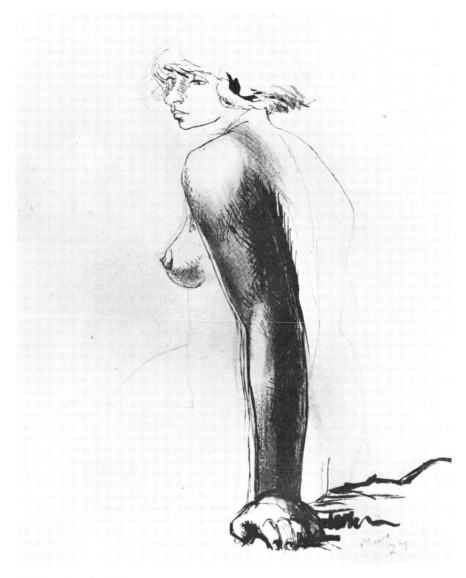

23 Seated nude 1927

16 Standing figure
1923
H $11\frac{5}{8} \times 6\frac{7}{8}$ in
Pencil, pen, and wash
The Artist

17 Seated figure
1923/4
H $13\frac{3}{4} \times 10$ in
Chalk and ink
The Artist

18 Standing woman
1924
H $22 \times 8\frac{1}{2}$ in
Black chalk and ink
Miss Mary Moore

19 Standing figures
1924
H $12\frac{3}{8} \times 19$ in
Pencil, ink, and wash
The Artist

20 Standing figure
1924
H 15×11 in approx
Pen, chalk, and wash
Mr Stephen Spender

21 The artist's mother
1927
H $11\frac{3}{4} \times 9$ in
Pen drawing on newspaper
The Artist

22 The artist's mother
1927
H $11 \times 7\frac{1}{2}$ in
Pencil, indian ink and wash
Miss Mary Moore

23 Seated nude life drawing
1927
H $16\frac{1}{2} \times 13\frac{3}{8}$ in
Ink and crayon on paper
Mr and Mrs Gordon Bunshaft

**24 Seated woman
drawing from life**
1928
H $21\frac{1}{4} \times 13\frac{1}{2}$ in
Chalk and wash
Mrs Irina Moore

25 Nude study
1929
H 22×15 in
Oil on paper
Whitworth Art Gallery,
Manchester

26 Woman in armchair
1930
H $15\frac{1}{4} \times 18\frac{1}{2}$ in
Oil on paper
Mrs Irina Moore

27 Seated figure
1933
H 22×15 in
Pen and wash
Mr Alan Wilkinson

Section two
Spatial and pictorial drawing

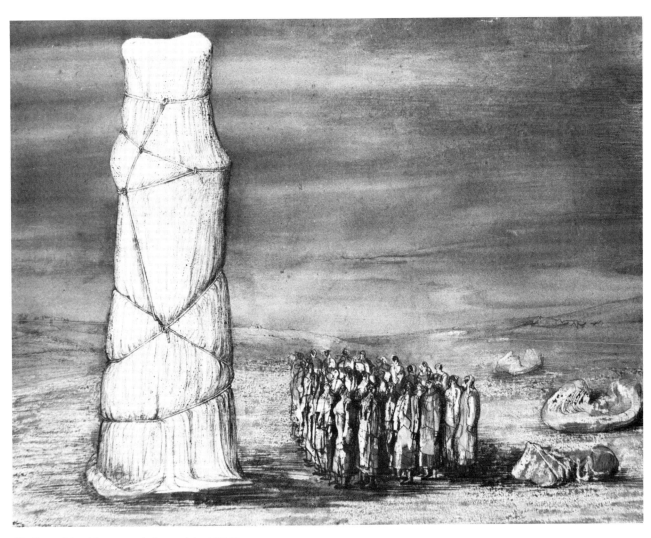

40 Crowd looking at a tied-up object 1942

By pictorial drawing I mean setting the subject in space. In this sense my 'black drawings' are pictorial, but pictorial drawings are not invariably dark or black. Turner, for example, creates a great sense of space by bathing everything in a mysterious light, a kind of sunlit fog.

There has long been a general idea that sculptors' drawings are somehow different from painters' drawings: by a typical 'sculptor's drawing' most people mean a crisp linear diagrammatic representation of a single object or figure, while a 'painter's drawing' is tonal, pictorial and 'sketchy'.

I have always disliked this distinction, for it implies that only painters are interested in space and the outside world. Speaking for myself, though primarily a sculptor I have always loved landscape and have sometimes tried to draw it: I've a clear memory of my attempt, as a 12-year-old schoolboy, to copy a colour postcard of Turner's *Fighting Temeraire*.

In many of my drawings for sculpture I have placed objects in space, sometimes indoors and sometimes in a landscape. I think my attempt to draw spatially is parallel to my early tendency to make holes in carvings: a hole in a piece of stone gives it thickness and depth by connecting the back to the front.

The sculptor is – or should be – no less concerned with space than the painter. He should show that whatever he is drawing has a far side to it, by making it an object surrounded by space rather than an object in relief – that is, half an object stuck on the paper. He must demonstrate its existence beyond the surface of the paper by using any technique of wash, smudge or shading that can break the tyranny of the flat plane of the paper and open up the suggestion of space.

Mystery plays a large and enlivening part in our lives: not knowing but wanting to know, wondering and guessing, questioning and exploring. We are perpetually intrigued and fascinated by the unknown.

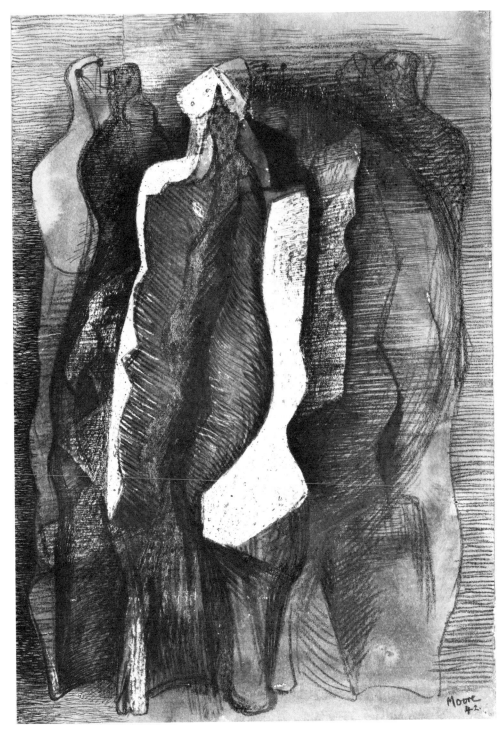

39 Standing figures 1942

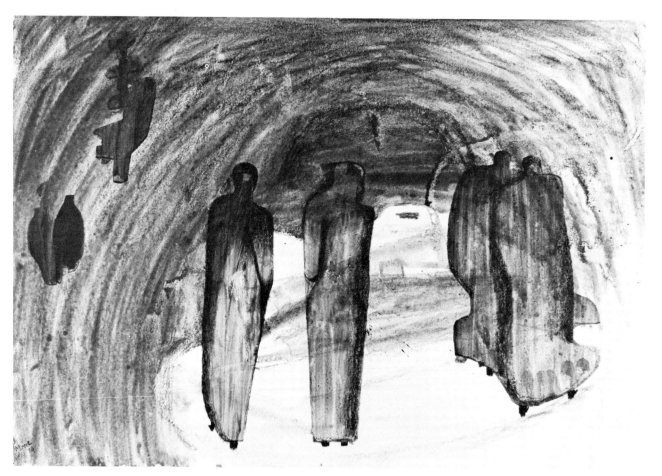

30 Figures in a cave 1936

28 **Montage of reclining figure and ideas for sculpture**
1932
H $14\frac{1}{2} \times 21\frac{1}{2}$ in
Pen, watercolour, and wash
Mrs Denis Clarke Hall

29 **Two stone forms**
1936
H 22×15 in
Pen, chalk, and wash
Lord Clark

30 **Figures in a cave**
1936
H 15×22 in
Wash
The Artist

31 **Stones in landscape**
1936
H 22×15 in
Pen and wash
Private Collection

32 **Square forms**
1936
H $17\frac{1}{2} \times 11$ in
Chalk and watercolour
Mrs Irina Moore

33 **Two women: drawing for sculpture combining wood and metal**
1937
H $17\frac{3}{4} \times 15$ in
Chalk and watercolour
Lord Clark

34 **Two heads – drawing for metal sculpture**
1939
H 11×15 in
Chalk, pen, and coloured inks
Mrs Irina Moore

35 **Sculptural object in landscape**
1939
H 15×22 in
Chalk, pen, and watercolour
Sir Robert and Lady Sainsbury

36 **Three standing figures**
1940
H $15 \times 10\frac{3}{4}$ in
Pen, chalk, and watercolour
The Trustees of Sir Colin and Lady Anderson

37 **Four grey sleepers**
1941
H 17×20 in
Chalk, pen and wash
City Art Gallery, Wakefield

38 **Arrangement of figures**
1942
H $13\frac{1}{2} \times 22$ in
Chalk and wash
Mrs Irina Moore

39 **Standing figures**
1942
H 22×15 in
Black chalk, pen, ink, and wash
Mr George E. Dix

40 **Crowd looking at a tied-up object**
1942
H 17×22 in
Chalk, pen, and watercolour
Lord Clark

41 **Figures with architecture**
1943
H $17\frac{1}{2} \times 25$ in
Pen, chalk, and watercolour
Mr and Mrs Neville Burston

42 **Three seated figures**
1971
H $11\frac{3}{4} \times 17$ in
Black chalk and wash
The Artist

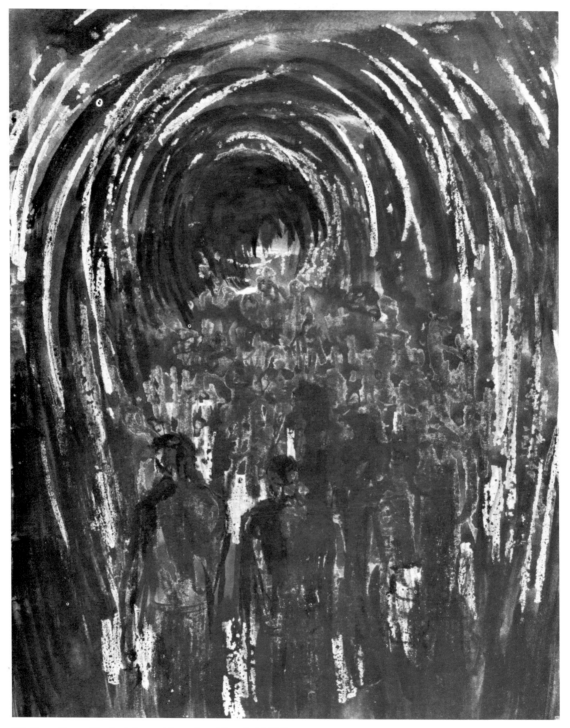

43 Page from *Coalmining subject* sketchbook 1941/2

Section three
The coalmine drawings

By the end of 1941 I had spent almost a year doing the Shelter drawings, and I was losing my initial enthusiasm and excitement. The shelters themselves had been tidied up and organized so that all their strangeness had gone. My great friend Herbert Read suggested that I should visit my native town of Castleford in Yorkshire and go down the mines, which were of essential importance in winning the war.

And so for about two weeks I went every day down Wheldale Colliery at Castleford and sketched the miners at their various tasks, especially those working at the coal face.

This pit is one of the deepest in the Castleford area. When the pit-cage reaches the bottom of the shaft there is still close on a mile to walk, and finally one has to crawl on hands and knees to reach the coal face where the roof is only 3 feet high. The thick choking dust, the noise of the coal-cutting machines and the men shovelling and pickaxing, the almost unbearable heat and the dense darkness hardly penetrated by the faint light from the miners lamps, the consciousness of being nearly a mile below ground, all made it seem at first like some terrible man-made inferno. But after the first few days I got used to it, and before the end I was taking it as naturally as the miners themselves.

To record in drawing what I felt and saw was a new and very difficult struggle. There was first the difficulty of seeing forms emerging out of deep darkness, then the problem of conveying the claustrophobic effect of countless wooden pit-props, 2 or 3 feet apart, receding into blackness, and of expressing the gritty, grubby smears of black coal-dust on the miners' bodies and faces at the same time as the anatomy underneath. I made the larger coalmine drawings back home in Hertfordshire, from sketches and diagrams and written notes done in the mine.

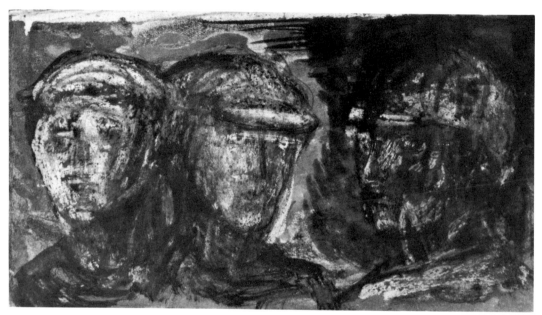

43 Detail of page from *Coalmining subject* sketchbook 1941/2

I now believe that the effort of making these drawings was of great value for my later 'black' drawings and graphics. In 1941 I was not particularly aware of Seurat's drawings. It was only later that I came to admire him, especially in the last ten years since I have owned two of his drawings myself. I look at these almost every day, and I feel that my recent 'black' drawings also owe a lot to him.

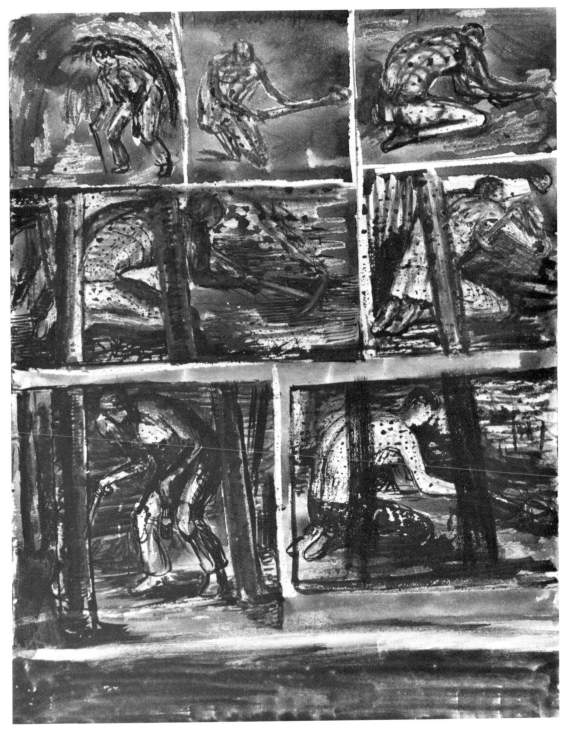

43 Page from *Coalmining subject* sketchbook 1941/2

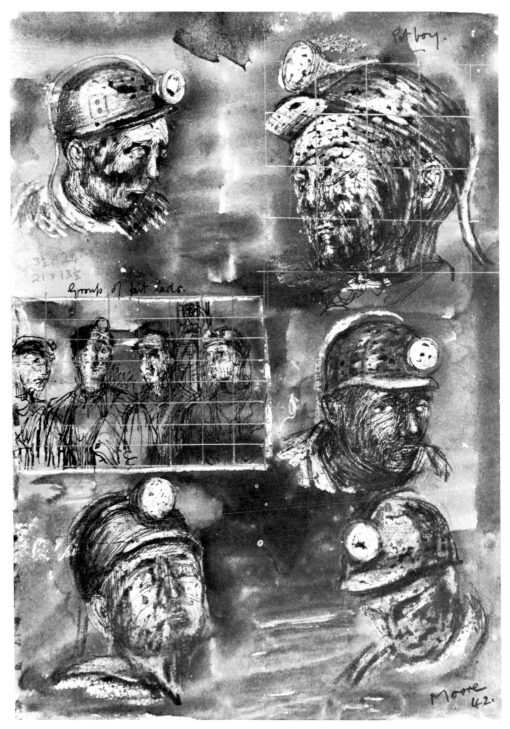

44 Page from *Coalmine* sketchbook (miner's heads) 1942

43 **Pages from 'Coalmining subject'
sketchbook**
Nos 2, 4, 6, 12, 16, 18, 24, 26, 32,
36, 38
1941/2
H $8 \times 6\frac{3}{8}$ in
Chalk, crayon, pen, pencil, wash,
and watercolour
The Artist

44 **Six pages from 'Coalmine'
sketchbook**
1942
H $9\frac{7}{8} \times 7$ in
Crayon, watercolour, chalk, and
pencil
Mrs Irina Moore

45 **Three pages from 'Coalmine'
sketchbook**
1942
H $9\frac{7}{8} \times 7$ in
Crayon, watercolour, chalk, and
pencil
West Riding of Yorkshire
Education Committee

46 **Pit boys at pithead**
1942
H $17\frac{1}{4} \times 24\frac{3}{4}$ in
Chalk, watercolour, and ink
City Art Gallery, Wakefield

47 **Miner at work**
1942
H $12\frac{1}{2} \times 10\frac{1}{2}$ in
Pen, chalk, crayon, watercolour,
and wash
Mrs Irina Moore

48 **Coalminer carrying lamp**
1942
H $19 \times 15\frac{1}{2}$ in
Pen, crayon, chalk, and
watercolour
Mrs Irina Moore

49 **Coalminers at work**
1942
H $5\frac{5}{8} \times 7\frac{5}{8}$ in
Pen, crayon, chalk, and
watercolour
Mrs Irina Moore

50 **'Coalmining' sketchbook**
1942
H 8×5 in
Cardboard-covered note-book
containing 56 pages
The Artist

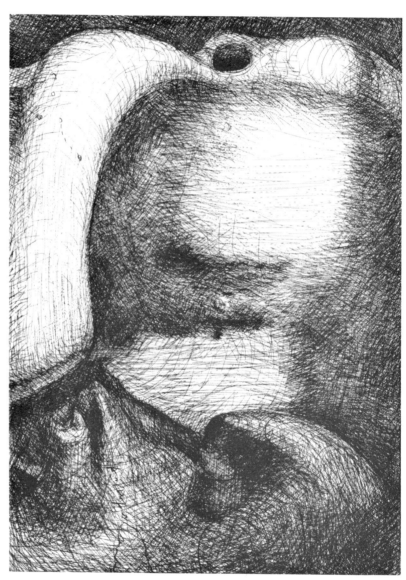

52 *Elephant Skull* plate XXVII. View of male torso 1970

Section four
Black and white graphics

The Stonehenge series of drawings and lithographs and the Auden illustrations were done only a few months apart. The Stonehenge drawings gave me a taste for using deep blacks and increased my feeling for the medium of lithography. The 'Elephant Skull' series has also some connexion with the Auden illustrations. What excited me about the elephant's skull and made me want to study it by drawing was the surprising contrasts of form contained in it – some parts were very thick and strong, others almost paper thin – and its intricate and mysterious interior structure, with perspectives and depths like caves and columns and tunnels.

The Elephant Skull series are etchings; the Stonehenge and the Auden series are lithographs. Of the two mediums I prefer etching. Technically and physically I like using the fine point of an etching needle on metal rather more than soft chalk on stone. I began the Stonehenge series with etching in mind, but as I looked at, and drew, and thought about Stonehenge, I found that what interested me most was not its history, nor its original purpose – whether chronological or religious – or even its architectural arrangement, but its present-day appearance. I was above all excited by the monumental power and stoniness of the massive man-worked blocks and by the effect of time on them. Some 4000 years of weathering has produced an extraordinary variety of interesting textures; but to express these with an etching needle was very laborious, and after making two or three etchings I changed to lithography which I found more in sympathy with the subject – lithography, after all, is drawing on stone.

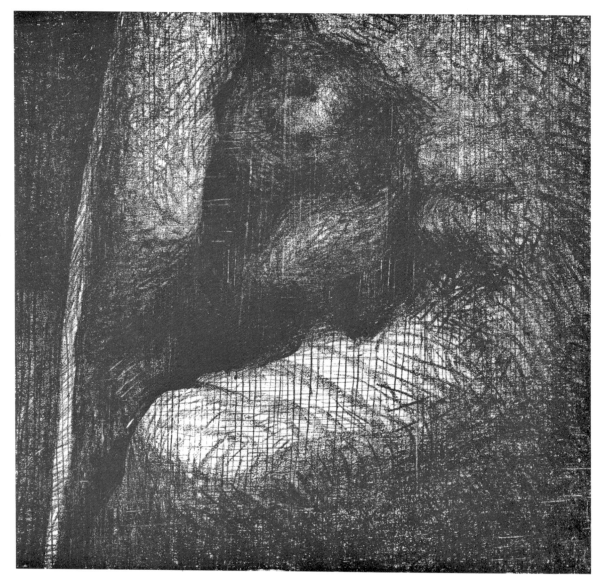

59 Stonehenge xv. Detail of dark cavern 1973

51 **Elephant skull — two interlocking figures**
Plate XXV
1970
H $9\frac{1}{4} \times 11$ in
Etching
CGM No 138

52 **Elephant skull — view of male torso**
Plate XXVII
1970
H $13\frac{5}{8} \times 9\frac{3}{4}$ in
Etching
CGM No 140

53 **Architecture**
1971
H 6×6 in
Softground etching and drypoint
CGM No 169

54 **Tunnel arch and window**
1971
H 6×6 in
Etching, aquatint, and drypoint
CGM No 174

55 **Architecture: doorway**
1972
H $7\frac{1}{2} \times 8\frac{3}{8}$ in
Etching, aquatint, drypoint, and soft ground etching
CGM No 185

56 **Stonehenge VI — fallen giant**
1973
H $11\frac{1}{2} \times 18$ in
Lithograph

57 **Stonehenge XII — moonlit blackness**
1973
H $11\frac{1}{2} \times 16$ in
Lithograph

58 **Stonehenge XIII — arm and body**
1973
H $11\frac{1}{2} \times 17\frac{1}{8}$ in
Lithograph

59 **Stonehenge XV — dark cavern**
1973
H $11\frac{1}{4} \times 17\frac{7}{8}$ in
Lithograph

Section five
The Book

When Véra Lindsay suggested that I should illustrate a selection of Auden poems I was at once interested in the idea, because I had known him ever since the 1930s and had always greatly admired him and his poetry; but it was some months before I felt I could really get going. I began with the most obvious poem – *Lullaby*, to me a very touching and beautiful one – in a straightforward way as if I were illustrating *Alice in Wonderland* or any other story. But after reading some of the other poems I realized that it would be impossible to treat them in the same way and I began to wonder what other ways there were of approaching the problem.

The Shield of Achilles led me to do *Multitude*, and from then on the poems began to fit in with the mood and direction of my Stonehenge series. I decided not so much to illustrate as to complement, or even contrast. Two people who are very unlike each other can come together over something common to them both; the fact that Auden was a Yorkshireman, as I am, and that the Yorkshire landscape has always been a very exciting element in my life, made a strong link between us.

I found working on a book very different from doing a single drawing or print, or even a series of them without any text. One has always to think in terms of the book as a whole, and of the images not only in themselves but in relation to the text and as they will appear in their sequence, in relation to each other. The necessity of co-operating with the Petersburg Press, with Véra and Paul and the printer, was also a new experience for me. The many changes that happened from one week to the next, either as a result of the exchange of ideas or as new technical possibilities became apparent, have made this a most fruitful and enjoyable collaboration.

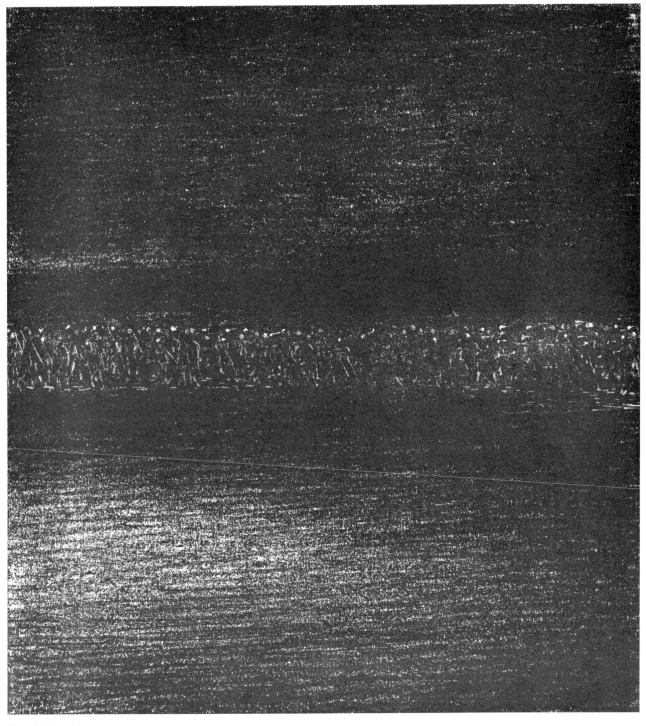

68 Multitude II

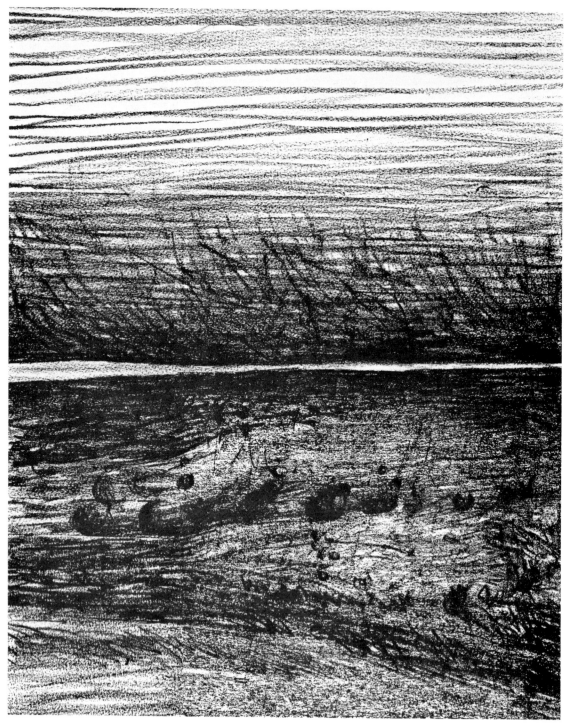

60 Windswept landscape

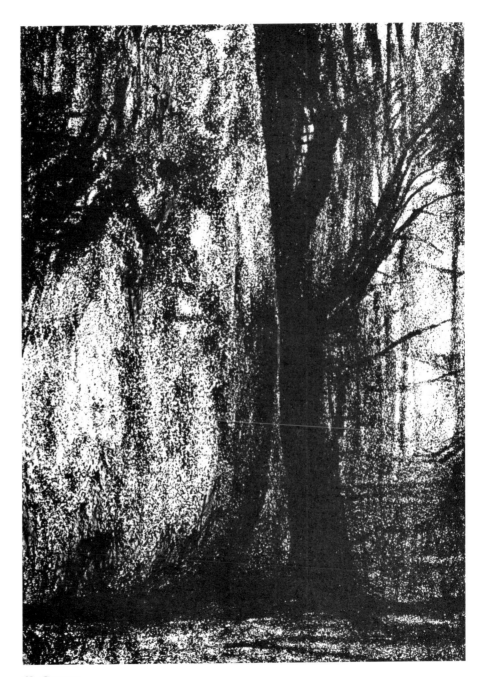

63 Cavern

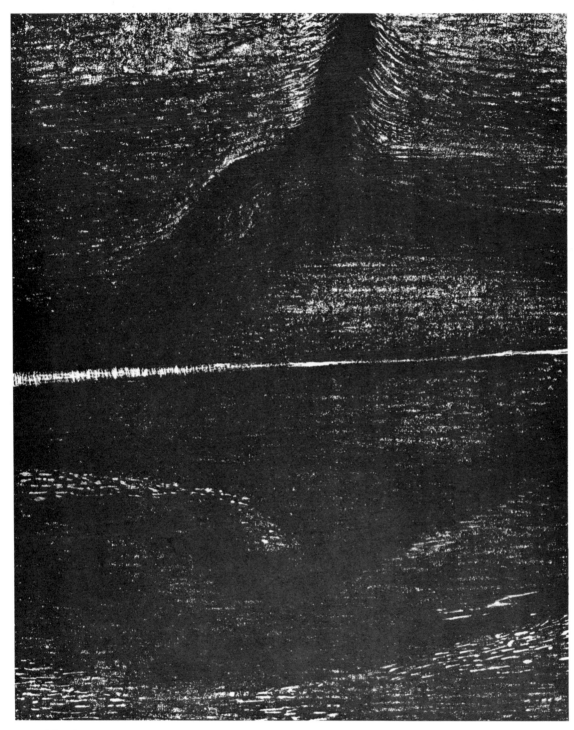

71 Divided landscape

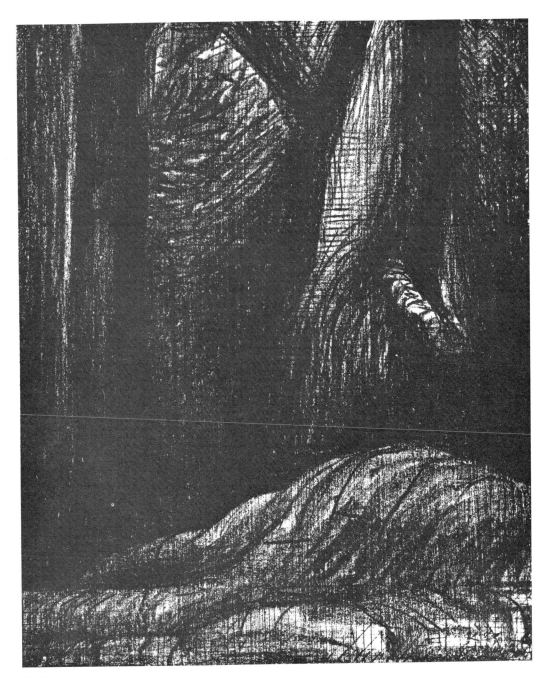

77 Forest

74 Split stone

AUDEN POEMS/MOORE LITHOGRAPHS
is a selection of poems by
W. H. Auden with images by
Henry Moore. The lithographs
were drawn between May and
December 1973.

60 Windswept landscape
H $16\frac{1}{4} \times 13\frac{1}{4}$ in

61 Garsdale
H $9\frac{3}{4} \times 12\frac{1}{2}$ in

62 Yorkshire moors
H $5\frac{3}{8} \times 66\frac{1}{4}$ in

63 Cavern
H $12\frac{5}{8} \times 10\frac{1}{2}$ in

64 Two seated figures II
H $6\frac{3}{4} \times 7\frac{3}{4}$ in

65 Lullaby: sleeping head
H $10\frac{3}{4} \times 11\frac{1}{2}$ in

66 Woman
H $14\frac{1}{8} \times 5\frac{7}{8}$ in

67 Green hill
H $10 \times 8\frac{5}{8}$ in

68 Multitude II
H $11\frac{1}{2} \times 10\frac{5}{8}$ in

69 Thin-lipped armourer II
H $8\frac{1}{2} \times 11\frac{1}{2}$ in

70 Entry to dreams
inside: H $16\frac{1}{4} \times 27\frac{5}{8}$ in
outside: H $16\frac{1}{4} \times 20\frac{3}{4}$ in

71 Divided landscape
H $16\frac{1}{4} \times 13\frac{3}{8}$ in

72 Tunnel
H $5\frac{1}{8} \times 8$ in

73 Millstream
H $10\frac{1}{4} \times 7\frac{3}{4}$ in

74 Split stone
H $11\frac{7}{8} \times 5\frac{5}{8}$ in

75 Fjord
H $8\frac{3}{4} \times 10$ in

76 Crevasse
H $11\frac{3}{8} \times 8\frac{1}{4}$ in

77 Forest
H $11\frac{3}{8} \times 8\frac{1}{4}$ in

78 People
H $5\frac{3}{4} \times 9\frac{3}{8}$ in

79 Man
H $14\frac{1}{8} \times 4\frac{3}{8}$ in

**80 Sketches of Auden made from
memory**
H $11 \times 8\frac{1}{4}$ in

A separate portfolio, designed by
Moore, contains twelve of the
lithographs listed above together
with the following eight others,
which were not used in the book.

81 Two seated figures I
H $10 \times 7\frac{3}{4}$ in

82 Multitude I
H $11\frac{1}{8} \times 8\frac{7}{8}$ in

83 Thin-lipped armourer I
H $8\frac{1}{4} \times 11\frac{1}{2}$ in

84 Man and woman
H $10\frac{1}{4} \times 10\frac{1}{4}$ in

85 Lullaby sketches
H $11\frac{5}{8} \times 11$ in

86 Lullaby
H $10\frac{3}{8} \times 11\frac{7}{8}$ in

87 Two heads
H $4\frac{7}{8} \times 8\frac{1}{4}$ in

88 Bridge
H $9\frac{3}{4} \times 13\frac{1}{2}$ in

The book and portfolio are
published by Petersburg Press,
London and will appear in the
autumn of 1974.

Section six
Auden Memorabilia

This section includes working notebooks, unpublished poems, and photographs, together with Moore's drawing for the masks in the first Group Theatre production of *The Dance of Death*.

As both here & now Here, now, ourselves,
Age, locality demand it Age, location demand us,
to have no option.

 That time can spoil our looks

As you, though, as I. But whatever we feel bleeding, in the most for
be what we think of persons Easily, horseplay, or only love,
To Dame Philology, realm we stay the same shape, we can't go away
 while the doctors do his repairs,

with might of perception an insults

As you think, as I Enormous rooms
her here to respect Do not enhance our importance.
To liberal persons But remind us of railroad stations
 return where for all the welcome, we might
For But in Dame Philology be somebody else
 As you & as I As you, think, as as I
 he has to respect to him to respect
 To liberal persons

None of all to move free minds unhappy as a world so
As we to name refers,
 I It is crual in Nature
 To be a solitary feeder, where
 and creatures as solitary feeding eat alone, where
 an who sees at
 Any the plants, feeing is co-termini into long,
 Hitherto stop to to break off to sleep, or festas,
 greet a or mate
 That need for the lucky work to greet and bolt
 when they get to chose, but most creatures
 Eat alone

Catalogue of an exhibition
held at the British Museum
24 April to 30 June 1974

© The Trustees of the British Museum 1974
Henry Moore and John Russell texts © Petersburg Press 1974
W. H. Auden MS © estate of W. H. Auden 1974

SBN 0 7141 0738 7
Published by British Museum Publications Limited 1974
6 Bedford Square London WC1B 3RA

Set in Monotype Times 327
Designed by British Museum Design Office
Printed in England by Lund Humphries